Occult

Imaginería Oculta
Immagini Occulte
神秘的なイメージ

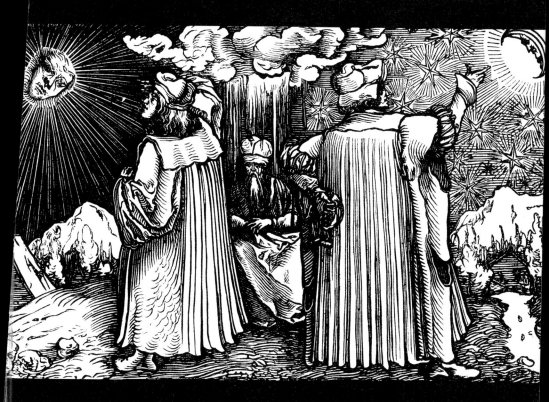

THE PEPIN PRESS / AGILE RABBIT EDITIONS

AMSTERDAM & SINGAPORE

Agile Rabbit Editions

90 5768 001 7	1000 Decorated Initials
90 5768 003 3	Graphic Frames
90 5768 005 x	Floral Patterns
90 5768 006 8	Chinese Patterns
90 5768 007 6	Images of the Human Body
90 5768 009 2	Indian Textile Prints
90 5768 010 6	Signs & Symbols
90 5768 011 4	Ancient Mexican Designs
90 5768 012 2	Geometric Patterns
90 5768 013 0	Art Nouveau Designs
90 5768 014 9	Menu Designs
90 5768 016 5	Graphic Ornaments
90 5768 017 3	Classical Border Designs
90 5768 018 1	Web Design Index
90 5768 020 3	Japanese Patterns
90 5768 021 1	5000 Animals
90 5768 022 x	Traditional Dutch Tile Designs
90 5768 024 6	Bacteria And Other Micro Organisms
90 5768 025 4	Compendium of Illustrations!

More titles in preparation. In addition to the Agile Rabbit series of book+CD-ROM sets, The Pepin Press publishes a wide range of books on art, design, architecture, applied art and popular culture. Please visit www.pepinpress.com for more information.

The Pepin Press – Agile Rabbit Editions, Amsterdam and Singapore
c/o P.O. Box 10349, 1001 EH Amsterdam, The Netherlands

Tel +31 20 4202021
Fax +31 20 4201152
mail@pepinpress.com
www.pepinpress.com

ISBN 90 5768 023 8

This book is edited, designed and produced by Agile Rabbit Editions
Design and production: Joost Baardman
Introduction: Joost Hölscher

10 9 8 7 6 5 4 3 2 1
2005 04 03 02

Printed in Singapore

Contents

Free CD-Rom in the inside back cover

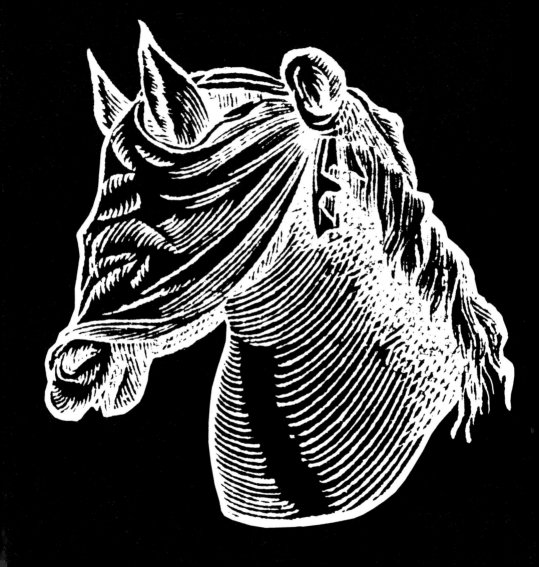

English

This book contains beautiful images for use as a graphic resource, or inspiration. All the illustrations are stored in high-resolution format on the enclosed free CD-ROM (Mac and Windows) and are ready to use for professional quality printed media and web page design. The pictures can also be used to produce postcards, either on paper or digitally, or to decorate your letters, flyers, etc.

They can be imported directly from the CD into most design, image-manipulation, illustration, word-processing and e-mail programs; no installation is required. Some programs will allow you to access the images directly; in others, you will first have to create a document, and then import the images. Please consult your software manual for instructions.

The images can be used free of charge, up to a maximum of ten images per application. Should you wish to use more than ten images, write for permission to the address indicated in this book.

The names of the files on the CD-ROM correspond with the page numbers in this book. For pages with more than one image, the order is from left to right and from top to bottom. This is indicated with a number following the page number, or with the following letter codes: T = top, B = bottom, C = centre, L = left, and R = right.

The CD-ROM comes free with this book, but is not for sale separately. The publishers do not accept any responsibility should the CD not be compatible with your system.

Español

En este libro podrá encontrar fantásticas imágenes que le servirán como fuente de material gráfico o como inspiración para realizar sus propios diseños. Se adjunta un CD-ROM gratuito (Mac y Windows) donde hallará todas las ilustraciones en un formato de alta resolución, con las que podrá conseguir una impresión de calidad profesional y diseñar páginas web. Las imágenes pueden también emplearse para realizar postales, de papel o digitales, o para decorar cartas, folletos etc.

Estas imágenes se pueden importar desde el CD a la mayoría de programas de diseño, manipulación de imágenes, dibujo, tratamiento de textos y correo electrónico, sin necesidad de utilizar un programa de instalación. Algunos programas le permitirán acceder a las imágenes directamente; otros, sin embargo, requieren la creación previa de un documento para importar las imágenes. Consulte su manual de software en caso de duda.

Las imágenes se pueden emplear de manera gratuita hasta un máximo de diez imágenes por aplicación.

Si desea utilizar más de diez imágenes, solicite la debida autorización escribiendo a la dirección que se indica en este libro.

Los nombres de los archivos del CD-ROM se corresponden con los números de página de este libro. En aquellas páginas en las que haya más de una imagen, el orden que se ha de seguir para localizarlas es de izquierda a derecha y de arriba abajo. Esto se indica con un número a continuación del número de página, o con las siguientes abreviaturas: T (*top*)= arriba; B (*bottom*)= abajo; C (*centre*)= centro; L (*left*)= izquierda y R (*right*)= derecha.

El CD-ROM se ofrece de manera gratuita con este libro, pero está prohibida su venta por separado. Los editores no asumen ninguna responsabilidad en el caso de que el CD no sea compatible con su sistema.

Deutsch

Dieses Buch enthält ansprechende Bilder, die als Ausgangsmaterial für graphische Zwecke oder als Anregung genutzt werden können. Alle Abbildungen sind in hoher Auflösung auf der beiliegenden Gratis-CD-ROM (für Mac und Windows) gespeichert und lassen sich direkt zum Drucken in professioneller Qualität oder zur Gestaltung von Websites einsetzen. Sie können sie auch als Motive für Postkarten auf Karton oder in digitaler Form, oder als Ausschmückung für Ihre Briefe, Flyer etc. verwenden.

Die Bilder lassen sich direkt in die meisten Zeichen-, Bildbearbeitungs-, Illustrations-, Textverarbeitungs- und E-Mail-Programme laden, ohne dass zusätzliche Programme installiert werden müssen. In einigen Programmen können nen die Dokumente direkt geladen werden, in anderen müssen Sie zuerst ein Dokument anlegen und können dann die Datei importieren. Genauere Hinweise dazu finden Sie im Handbuch zu Ihrer Software.

Pro Publikation dürfen Sie bis zu zehn Bilder kostenfrei nutzen. Wenn Sie mehr als zehn Bilder verwerten möchten, holen Sie bitte eine schriftliche Genehmigung bei der im Buch angegebenen Adresse ein.

Die Namen der Bilddateien auf der CD-ROM entsprechen den Seitenzahlen dieses Buchs. Bei Seiten mit mehreren Bildern verläuft die Reihenfolge von links nach rechts und oben nach unten. Wo die Position auf der jeweiligen Seite angegeben ist, bedeutet T (top)= oben, B (bottom)= unten, C (centre)= Mitte, L (left)= links und R (right)= rechts. Die CD-ROM wird kostenlos mit dem Buch geliefert und ist nicht separat verkäuflich. Der Verlag haftet nicht für Inkompatibilität der CD-ROM mit Ihrem System.

Italiano

Questo libro contiene immagini meravigliose che possono essere utilizzate come risorsa grafica o come fonte di ispirazione. Tutte le illustrazioni sono contenute nell'allegato CD-ROM gratuito (per Mac e Windows), in formato ad alta risoluzione e pronte per essere utilizzate per pubblicazioni professionali e pagine web. Possono essere inoltre usate per creare cartoline, su carta o digitali, o per abbellire lettere, opuscoli, ecc.

Dal CD, le immagini possono essere importate direttamente nella maggior parte dei programmi di grafica, di ritocco, di illustrazione, di scrittura e di posta elettronica; non è richiesto alcun tipo di installazione. Alcuni programmi vi consentiranno di accedere alle immagini direttamente; in altri, invece, dovrete prima creare un documento e poi importare le immagini. Consultate il manuale del software per maggiori informazioni.

Le immagini possono essere utilizzate gratuitamente fino ad un massimo di dieci per applicazione. Se desiderate utilizzare più di dieci immagini, dovrete richiedete la relativa autorizzazione all'indirizzo indicato.

I nomi dei documenti sul CD-ROM corrispondono ai numeri delle pagine del libro. Quando le pagine contengono più di un'immagine, l'ordine di queste ultime è da sinistra a destra e dall'alto verso il basso. L'ordine è indicato con un numero situato dopo il numero di pagina o con le seguenti lettere:

T (top)= alto, B (bottom)= basso, C (centre)= centro, L (left)= sinistra e R (right)= destra.

Il CD-ROM è allegato gratuitamente al libro e non può essere venduto separatamente. L'editore non può essere ritenuto responsabile qualora il CD non fosse compatibile con il sistema posseduto.

Français

Cet ouvrage renferme de superbes illustrations destinées à servir de ressources graphiques ou d'inspiration. La totalité des images sont stockées en format haute définition sur le CD-ROM gratuit inclus (Mac et Windows), prêtes à l'emploi en vue de réaliser des impressions ou pages Web de qualité professionnelle. Elles permettent également de créer des cartes postales, aussi bien sur papier que virtuelles, ou d'agrémenter vos courriers, prospectus et autres. Vous pouvez les importer directement à partir du CD dans la plupart des applications de création, manipulation graphique, illustration, traitement de texte et messagerie, sans qu'aucune installation ne soit nécessaire. Certaines applications permettent d'accéder directement aux images, tandis que dans d'autres, vous devez d'abord créer un document, puis importer les images. Veuillez consultez les instructions dans le manuel du logiciel concerné.

Ces images peuvent être utilisées sans frais, jusqu'à un maximum de dix par application. Si vous souhaitez en utiliser davantage, veuillez solliciter l'autorisation à l'adresse indiquée dans le présent ouvrage.

Sur le CD, les noms des fichiers correspondent aux numéros de pages de ce livre. Sur les pages qui comportent plusieurs images, l'ordre va de gauche à droite, et de haut en bas. Il est indiqué soit par un numéro figurant après le numéro de page, soit par les codes suivants : T *(top)*= haut, B *(bottom)*= bas, C *(centre)*= centre, L *(left)*= gauche, et R *(right)*= droite.

Le CD-ROM est fourni gratuitement avec le livre, mais il ne peut être vendu séparément. L'éditeur décline toute responsabilité si ce CD n'est pas compatible avec votre ordinateur.

Português

Este livro contém fantásticas imagens que podem ser utilizadas como fonte de material gráfico ou como inspiração para realizar os seus próprios desenhos. Você encontrará todas as ilustrações em formato de alta resolução dentro do CD-ROM gratuito (Mac e Windows), e com elas poderá conseguir uma impressão de qualidade profissional e desenhar páginas web. As imagens também podem ser usadas para criar postais, de papel ou digitais, ou para decorar cartas, folhetos, etc.

Estas imagens podem ser importadas do CD para a maioria de programas de desenho, manipulação de imagem, ilustração, processamento de texto e correio eletrônico, sem a necessidade de utilizar um programa de instalação. Alguns programas permitirão que você tenha acesso às imagens diretamente; e em outros, você deverá criar um documento antes de importar as imagens. Por favor, consulte o seu manual de software para obter maiores informações.

Você pode utilizar as imagens de forma gratuita até um limite máximo de dez imagens por aplicativo. Se você deseja utilizar mais de dez imagens, solicite a devida autorização escrevendo para o endereço indicado neste livro.

Os nomes dos arquivos do CD-ROM correspondem aos números de página deste livro. Nas páginas onde exista mais de uma imagem, a ordem que deve ser seguida para localizar as imagens é da esquerda para a direita e de cima para baixo. Isso é indicado com um número que vem logo depois do número de página, ou com as seguintes abreviaturas: T *(top)*= acima; B *(bottom)*= abaixo; C *(centre)*= centro; L *(left)*= esquerda e R *(right)*= direita.

O CD-ROM é oferecido de forma gratuita com este livro, porém é proibido vendê-lo separadamente. Os editores não assumem nenhuma responsabilidade no caso de que o CD não seja compatível com o seu sistema.

日本語

本書にはグラフィック リソースやインスピレーションとして使用できる美しいイメージ画像が含まれています。すべてのイラストレーションは、無料の付属 CD-ROM（Mac および Windows 用）に高解像度で保存されており、これらを利用してプロ品質の印刷物や WEB ページを簡単に作成することができます。また、紙ベースまたはデジタルの葉書の作成やレター、ちらしの装飾等に使用することもできます。

これらの画像は、CD から主なデザイン、画像処理、イラスト、ワープロ、E メールソフトウェアに直接取り込むことができます。インストレーションは必要ありません。プログラムによっては、画像に直接アクセスできる場合や、一旦ドキュメントを作成した後に画像を取り込む場合等があります。詳細は、ご使用のソフトウェアのマニュアルをご参照下さい。

1 つのアプリケーションに対して最大 10 個までの画像を無料で使用することができます。10 個以上の画像を使用する場合は、本書に記載された住所に紙面で許可を求めてください。

CD-ROM 上のファイル名は、本書のページ数に対応しています。ページに複数の画像が含まれる場合は、左から右、上から下の順序で番号がつけられ、ページ番号に続く数字または下記のレターコードで識別されます。

T ＝トップ（上部）、B= ボトム（下部）、C ＝センター（中央）、L= レフト（左）R ＝ライト（右）

CD-ROM は本書の付属品であり、別売されておりません。CD がお客様のシステムと互換でなかった場合、発行者は責任を負わないことをご了承下さい。

中文簡介

本書包含精美圖片，可以作為圖片資源或激發靈感的資料使用。這些圖片存儲在所附的免費高容量 CD-ROM（可在 Mac 和 Windows 下使用）中，並可以用於專業的高質量媒體打印和網頁設計。這些圖片還可以用於製作紙質和數字明信片或裝飾您的信封、傳單等。

您無需安裝即可以直接從 CD 中調入使用其中大多數的設計、圖像處理、圖片、字處理和電子郵件程序。其中的一些程序使您可以直接使用圖片：另外一些，您則需要首先創建一個文件，然後引入圖片。用法說明請參閱軟件說明手冊。這些圖片每次免費應用時最多不能超過 10 幅。如果您想要使用超過 10 幅的圖片，請寫信至書中所示地址，以獲得許可。

在 CD-ROM 中的文件名稱是與書中的頁碼相對應的。如果書頁中的圖片超過一幅，其順序為從左到右、從上到下。這會在書頁號後加一個數字來表示，或者是加一個字母：T= 上、 B= 下、 C= 中、 L= 左、 R= 右。

與書一起的 CD-ROM 是免費的，但它不單獨銷售。如果 CD 與您的系統不兼容，出版商不承擔任何責任。

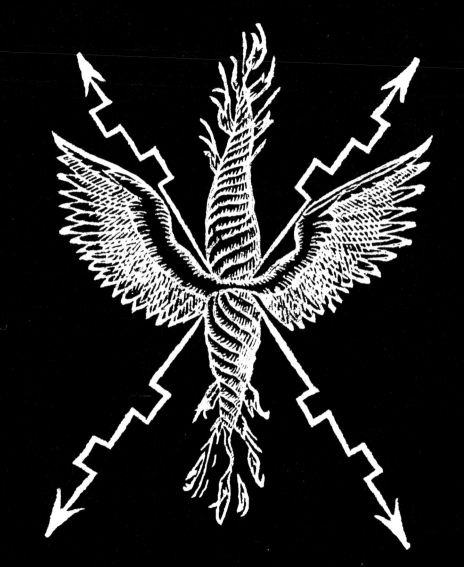

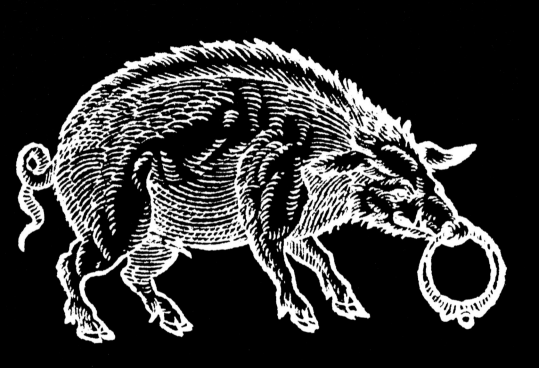

Occult Images

Symbolism has always played an fundamental role in the pursuit, study and practice of the occult. As the occult largely deals with that which is secret, not revealed and hidden, the mysterious and in particular the supernatural, knowledge of it could only be shared through 'intuitive understanding' rather than quantifyable scientific method. This obviously calls for an idiom specifically suited to the precepts of such abstruse matter. The extensive use of symbolic images proved an excellent manner of recording and relating this obscure and enigmatic lore while at the same time shielding it from the sceptical perception of the uninitiated.

Over the ages a wealth of occult images has emerged, largely originating from arcane volumes of ancient hermetic doctrine. Some of the themes found in these esoteric books influenced other sectors of scolarly endeavour of a less transcendental nature. One of these more mundane fields of interest was the once popular discipline of personal heraldry. Most of the illustrations in this book have been taken from an armorial of this category, *Les Devises Heroiques* by Claude Paradin, published in 1556. If the use of these pictures was not intentionally occult, its origins for the larger part were so indeed. All are steeped in deep mystery and possess a power that nowadays would no longer be considered dangerously magical, but which seems forcefully captivating none the less.

Images occultes

Le symbolisme a toujours joué un rôle primordial dans la quête, l'étude et la pratique des sciences occultes. L'occultisme étant principalement lié à toute chose secrète, non révélée ou cachée, mystérieuse et notamment surnaturelle, sa connaissance ne peut se partager qu'au moyen d'une « compréhension intuitive » plutôt que d'une méthode scientifique concrète. Il semble indispensable d'avoir recours à un langage spécifique, adapté aux préceptes de ce thème ô combien obscur. L'usage abondant d'images symboliques s'est avéré un excellent moyen de dépeindre et de faire connaître cette science sombre et énigmatique tout en la protégeant du scepticisme des profanes.

Au cours de l'histoire, une grande quantité d'images occultes sont nées, provenant en grande partie d'ouvrages ésotériques dédiés aux anciennes doctrines hermétiques. Quelques-uns des thèmes figurant dans ces ouvrages ont influencé des disciplines scientifiques de nature moins transcendantale. Parmi ces disciplines plus communes figure l'héraldique personnelle, qui connut du succès en son temps. La majorité des illustrations de cet ouvrage provient d'un armorial de cette catégorie, *Les Devises Héroïques* de Claude Paradin, publié en 1556. Bien que l'usage de ces représentations ne fût pas intentionnellement occulte, la plupart d'entre elles tiraient leurs origines de l'occultisme. Toutes sont imprégnées d'un profond mystère et sont dotées d'un pouvoir qui aujourd'hui ne serait plus considéré comme dangereux et magique, mais qui demeure malgré tout fascinant.

Okkulte Bilder

In der Beschäftigung mit dem Okkulten, seinem Studium und seiner Praxis haben Symbole immer eine entscheidende Rolle gespielt. Da das Okkulte sich überwiegend mit dem Geheimen, Unerforschten, Verborgenen, Mysteriösen und vor allem dem Übernatürlichen beschäftigt, war das Wissen darüber leichter durch "intuitives Verstehen" zu vermitteln als durch quantifizierbare wissenschaftliche Methodik. Dies verlangte natürlich nach einer den Prinzipien dieser mystischen Lehren angemessenen Sprachform: Unter Verwendung vieler Bildsymbole ließ sich der obskure, geheimnisvolle Wissensschatz ausgezeichnet festhalten und vermitteln, zumal die Symbole ihn gleichzeitig vor den skeptischen Blicken Uneingeweihter schützten.

Im Laufe der Jahrhunderte entstand so ein reicher Kodex okkulter Bildsymbole, die größtenteils aus uralten geheimnisvollen Büchern über antike hermetische Lehren stammen. Einige der in diesen esoterischen Bänden abgehandelten Wissensbereiche beeinflussten auch weniger transzendentale Wissenschaftszweige wie die einst beliebte persönliche Heraldik. Einem Buch über die persönliche Heraldik, Claude Paradins *Les devises heroiques* von 1556, entstammen auch die meisten Abbildungen des vorliegenden Buchs. Die Bilder sollten seinerzeit keine versteckten Inhalte vermitteln, sind aber ihrem Ursprung nach tatsächlich okkulte Symbole. Sie alle wurzeln in tiefen Mysterien und besitzen eine Kraft, die heutzutage zwar nicht mehr gefährlich oder magisch wirkt, wohl aber eine unwiderstehliche Faszination ausstrahlt.

Immagini Occulte

Il simbolismo ha sempre avuto un ruolo fondamentale per la ricerca, lo studio e la pratica dell'occulto. L'occulto si occupa di ciò che è segreto, non rivelato, arcano e soprattutto soprannaturale: pertanto la conoscenza in questo campo non può che essere condivisa in maniera intuitiva, piuttosto che con metodi scientifici e razionali, e richiede un linguaggio consono a precetti tanto astrusi. L'impiego di immagini simboliche si è dimostrato un'ottima maniera per raccontare questo mondo oscuro ed enigmatico, proteggendolo al tempo stesso dallo scetticismo dei profani. Nel corso del tempo è comparsa una gran quantità di immagini occulte, provenienti essenzialmente da volumi dedicati ad antiche dottrine ermetiche. Alcuni dei temi contenuti in queste opere esoteriche hanno finito per influenzare anche altri ambiti accademici meno trascendentali e più mondani: ad esempio, quello un tempo assai popolare dell'araldica personale. La maggior parte delle illustrazioni di questo volume sono tratte in effetti da un libro di araldica di questo genere, *Les Devises Heroiques* di Claude Paradin, pubblicato nel 1556. Se l'ambito di utilizzo di queste immagini non era occulto, la loro origine sì lo era: sono immagini completamente immerse nel mistero e il loro potere di attrazione, benché oggi non sia più considerato né magico né pericoloso, continua ad essere notevole.

Imaginería oculta

Desde siempre, el simbolismo ha desempeñado un papel fundamental en la búsqueda, la práctica y el estudio de lo oculto. Dado que por oculto se entiende todo lo secreto o aún no revelado, lo misterioso y, sobre todo, lo sobrenatural, la transmisión de su conocimiento sólo puede producirse "intuitivamente", pero nunca mediante métodos científicos cuantificables. Evidentemente, una disciplina como ésta, de carácter tan abstruso, requiere un lenguaje específico que se adecue a sus preceptos. El uso de imágenes simbólicas no sólo ha logrado perpetuar y difundir esta obscura y enigmática tradición, sino que, además, la ha mantenido a salvo del escepticismo de los que son profanos en la materia.

En el transcurso de la historia han visto la luz un gran número de imágenes ocultas, la mayoría procedentes de volúmenes arcanos de la antigua doctrina hermética. Algunos de los temas tratados en estos libros esotéricos influyeron sobre otras doctrinas del saber de naturaleza más trivial e intrascendente como, por ejemplo, la antiguamente tan popular heráldica personal. La mayoría de las ilustraciones de este libro han sido extraídas de un armorial de esta categoría, Les Devises Heroiques, de Claude Paradin, publicado en 1556. Y si no hubo una voluntad explícita de ocultar estas imágenes, no cabe duda de que sus orígenes se silenciaron intencionadamente. Todas están imbuidas de un profundo misterio e irradian una energía que hoy día ya no se consideraría como "peligrosamente mágica" y que, sin embargo, resulta poderosamente cautivadora.

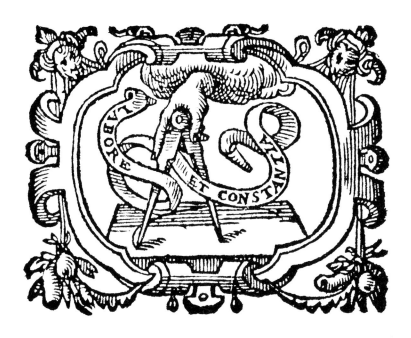

LABORE ET CONSTANTIA

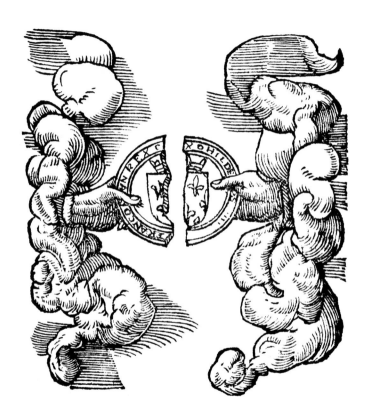

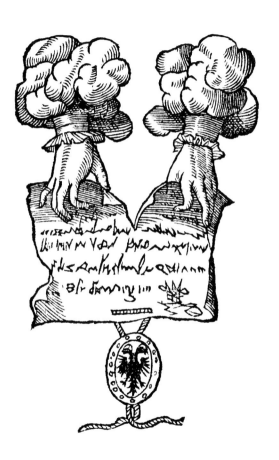

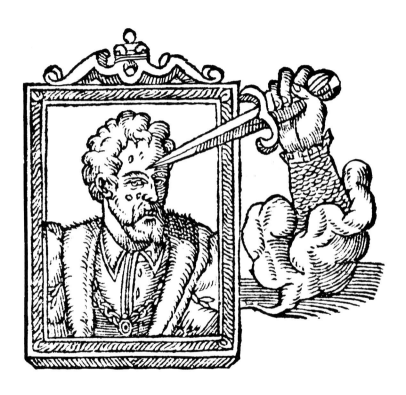

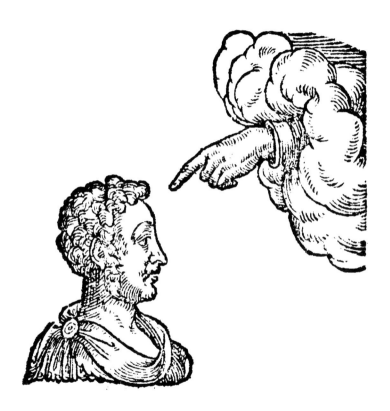

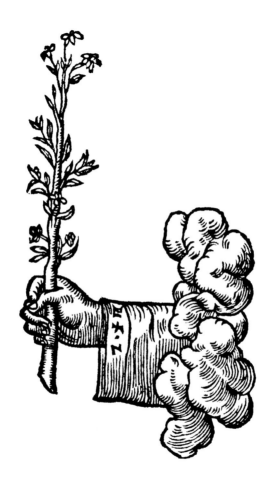

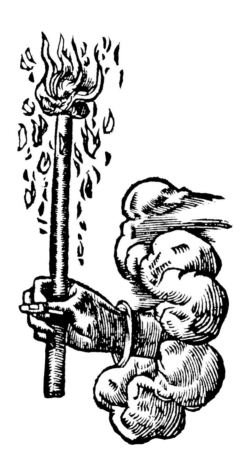

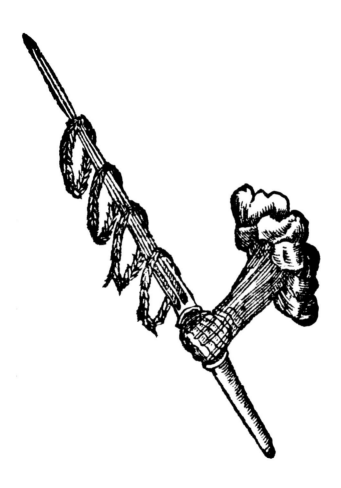

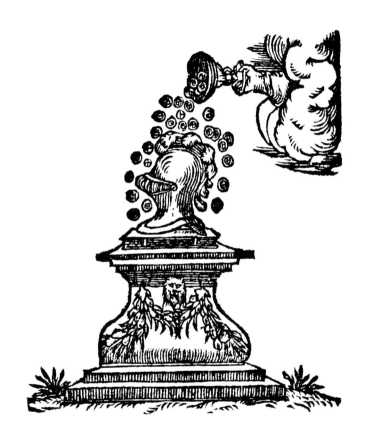

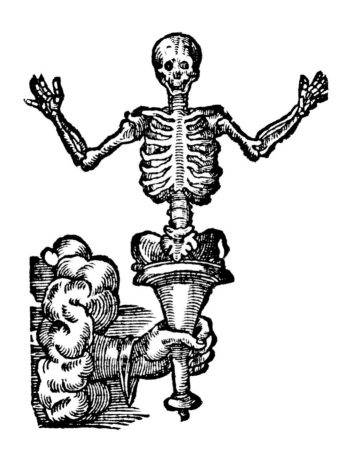

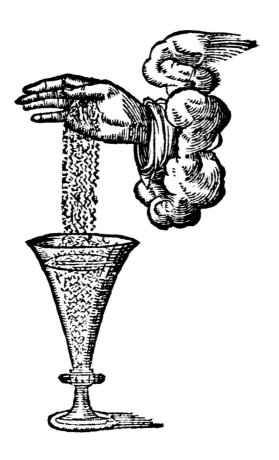

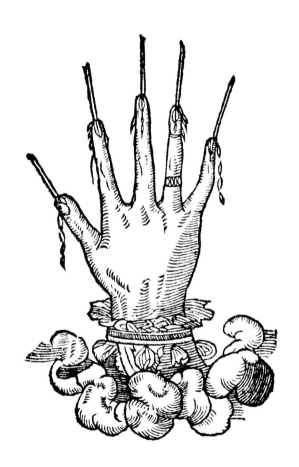

50

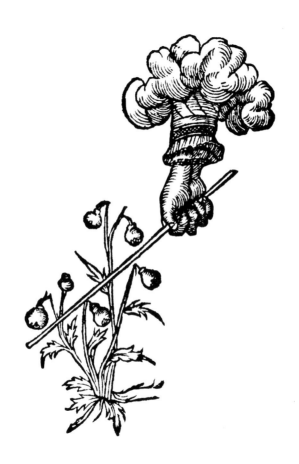

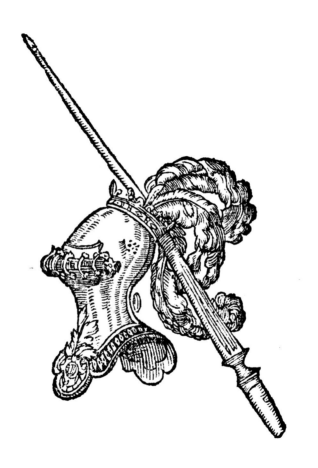

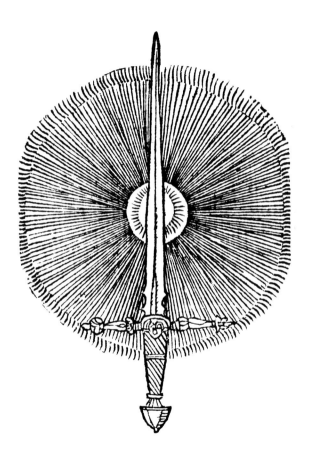

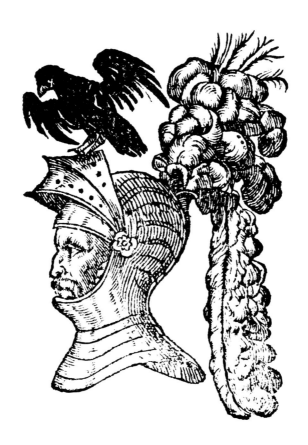

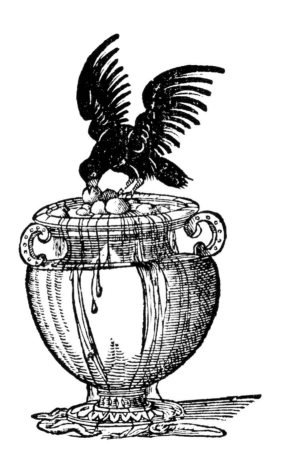

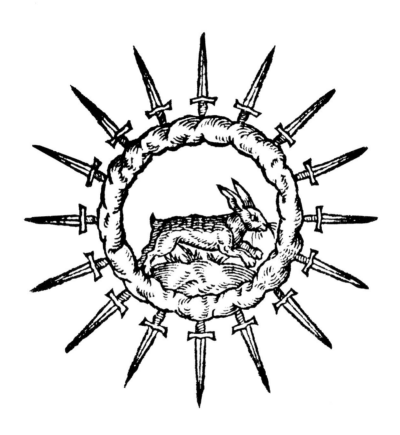

62

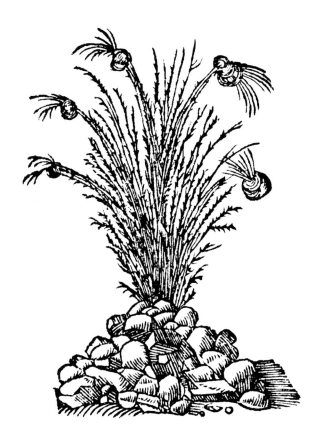

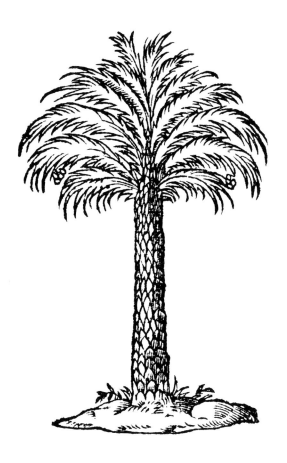

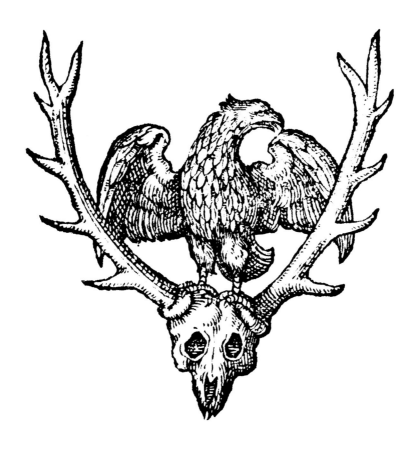

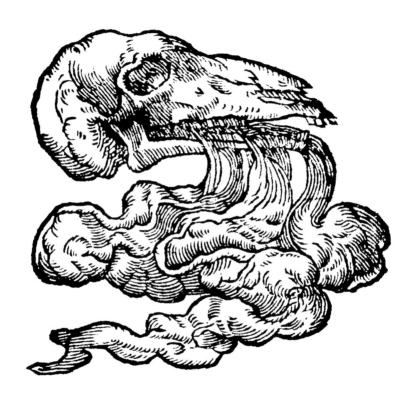

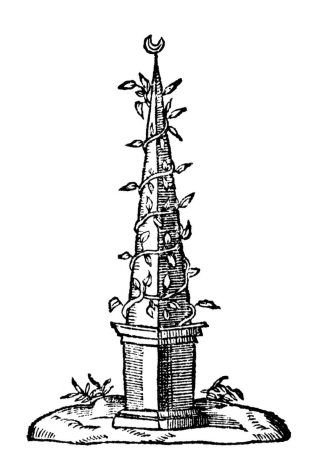

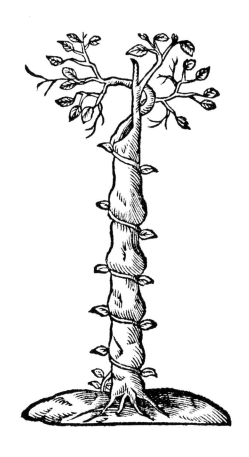

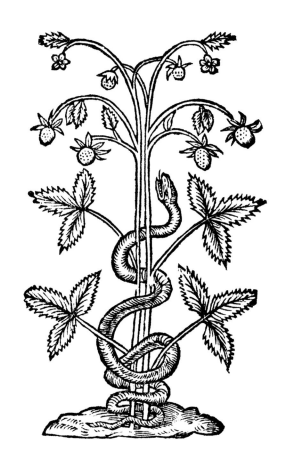

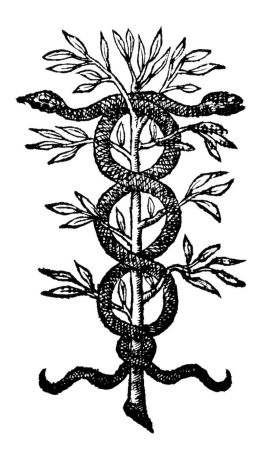

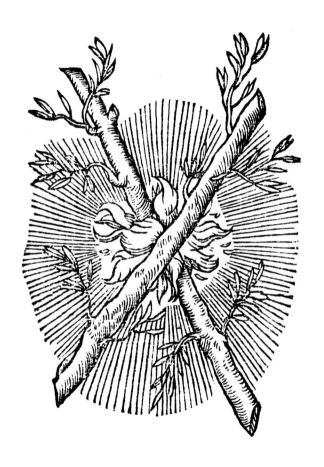

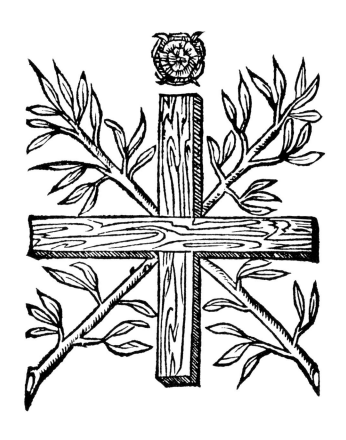

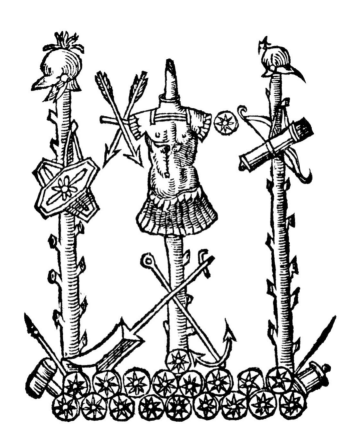

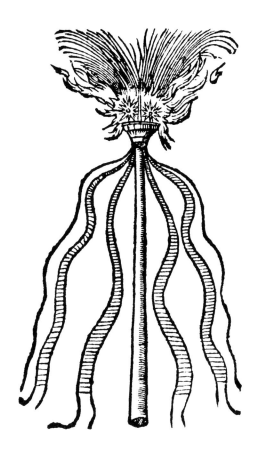

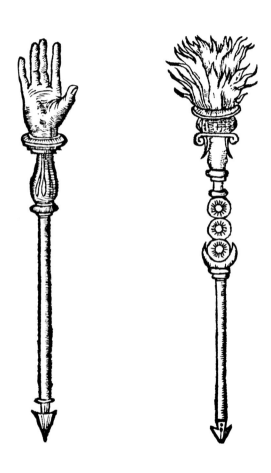

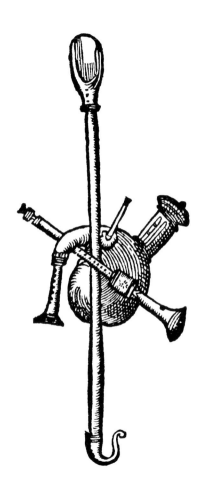

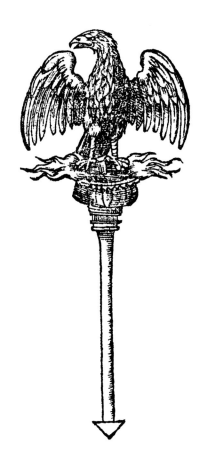

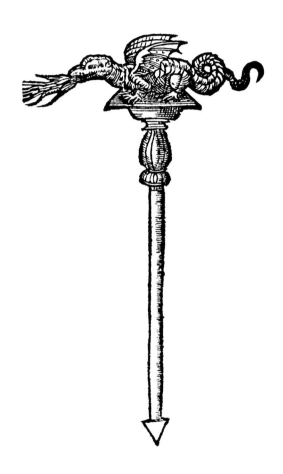

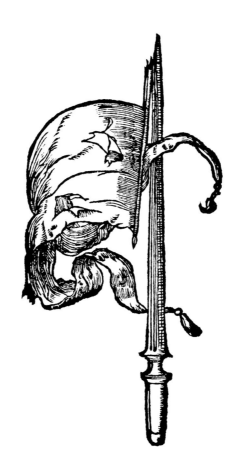

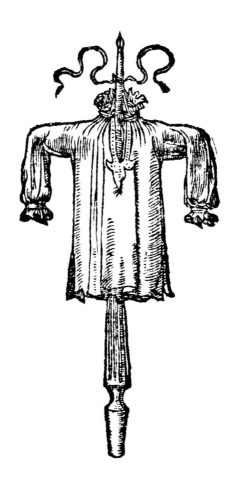

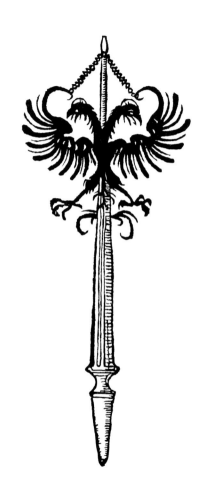

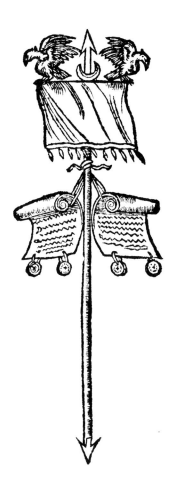

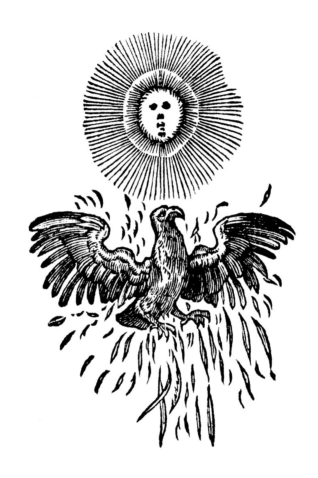

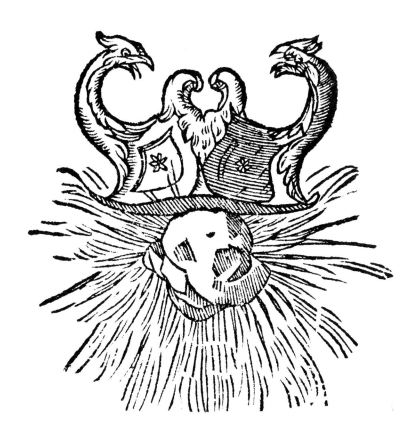

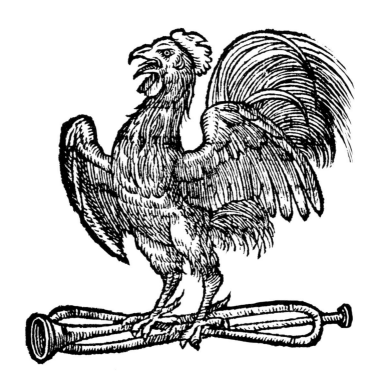

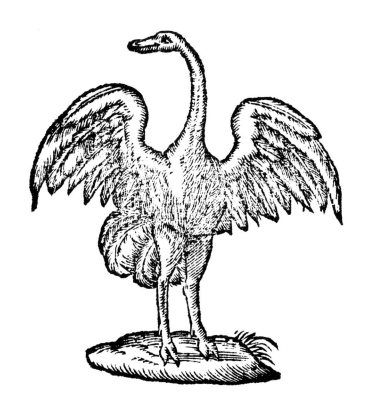

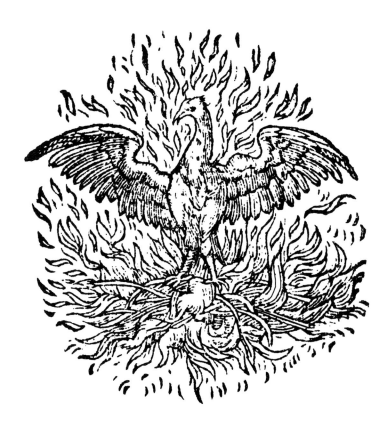

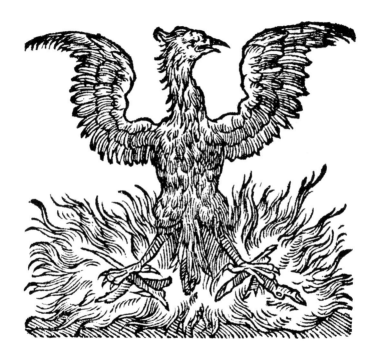

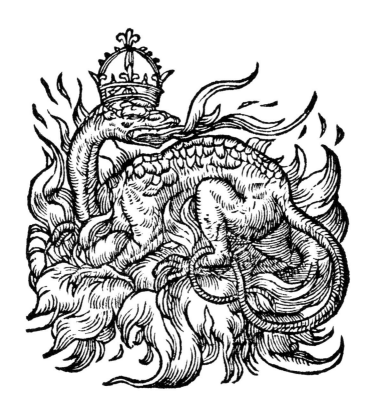

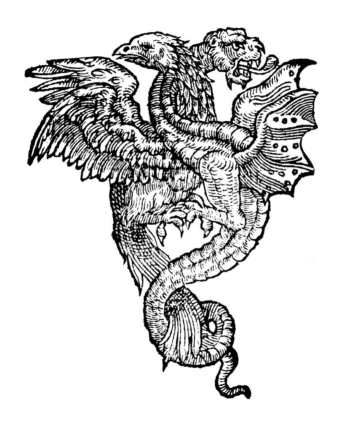

106

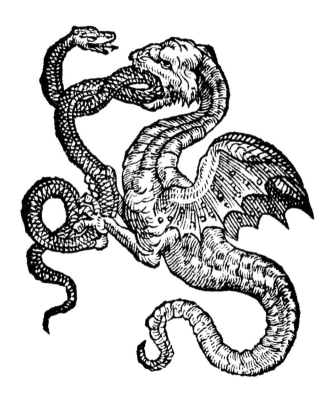

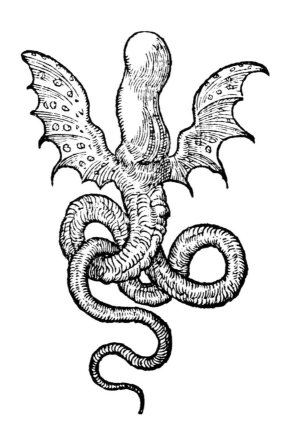

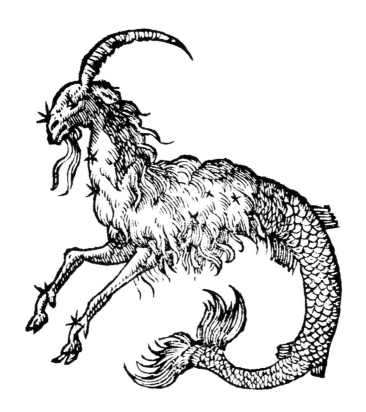

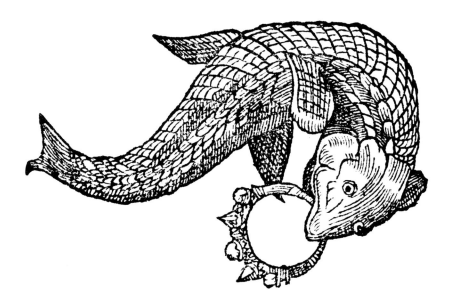

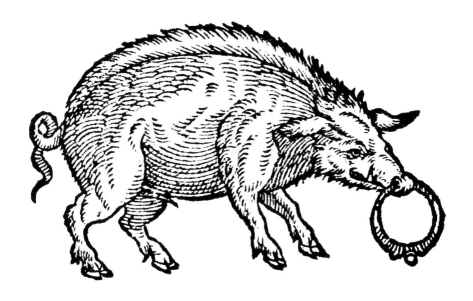

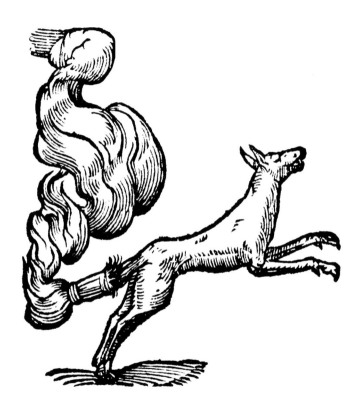

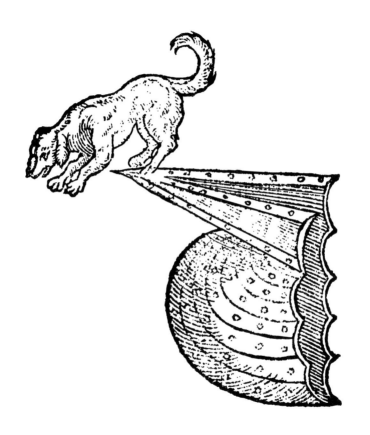

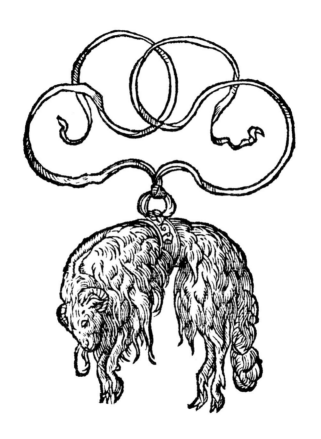

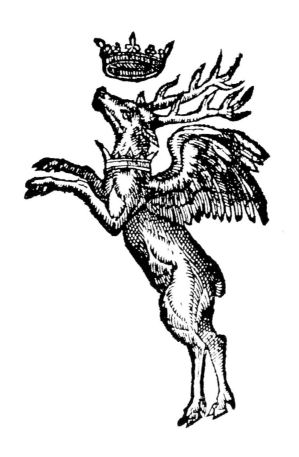

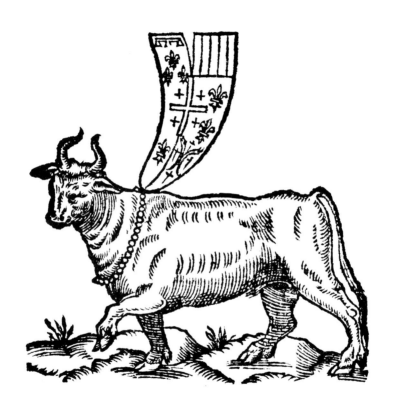

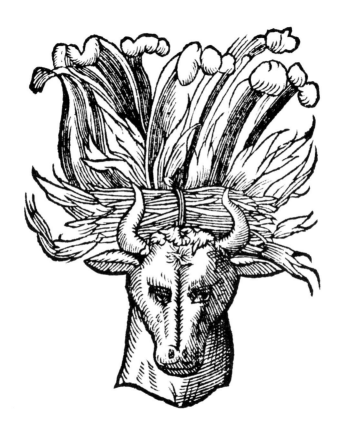

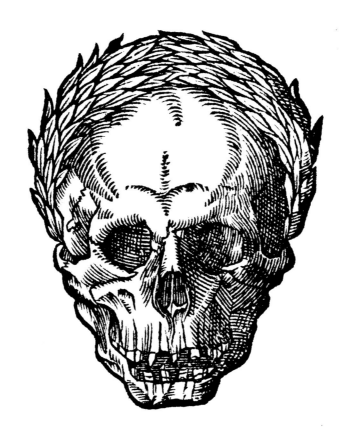

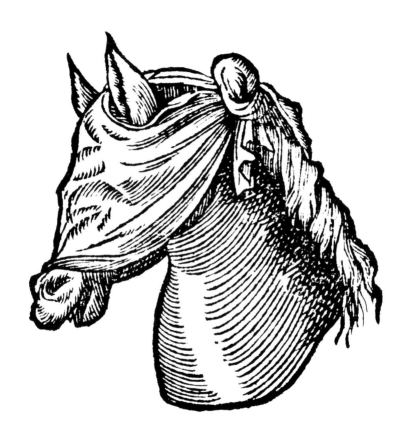

119

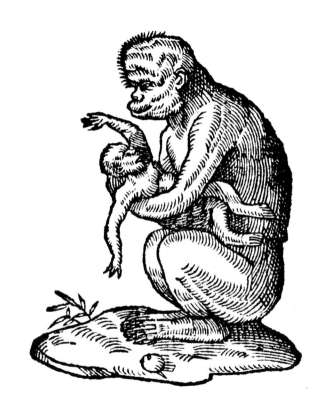

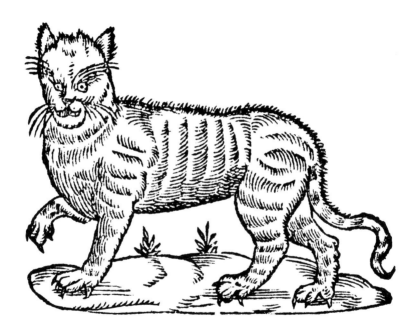

121

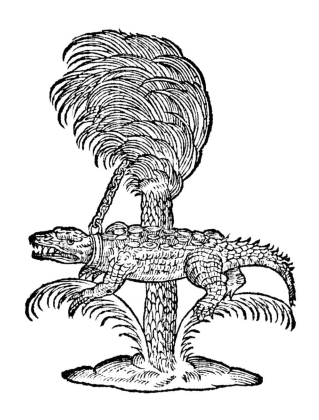

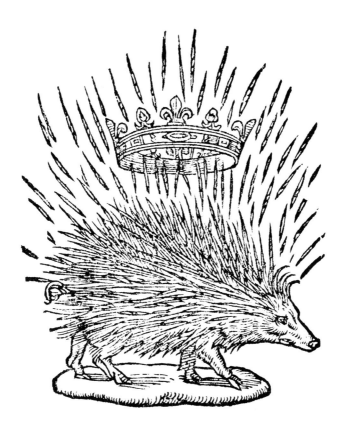

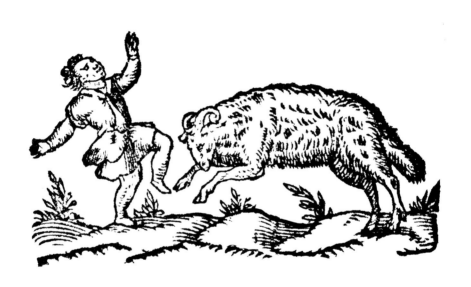

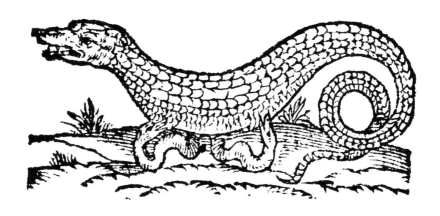

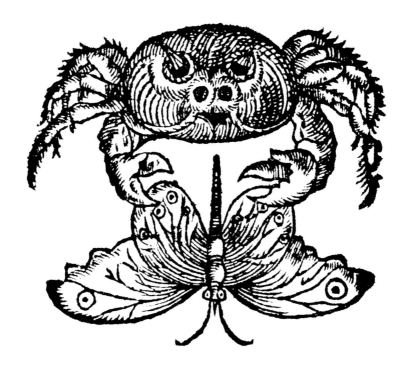

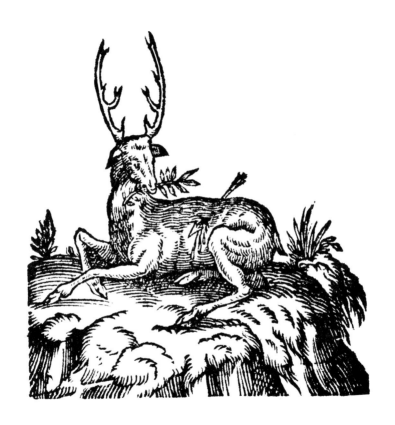

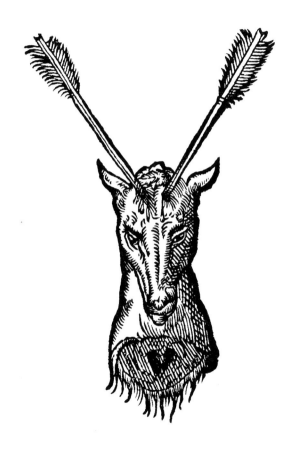

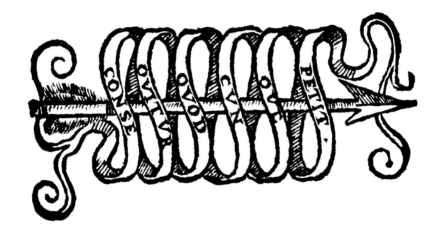

134

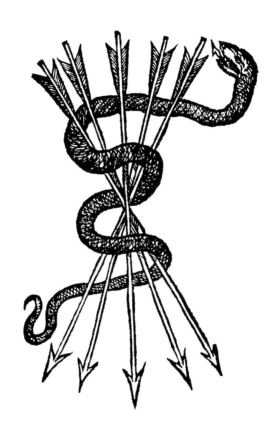

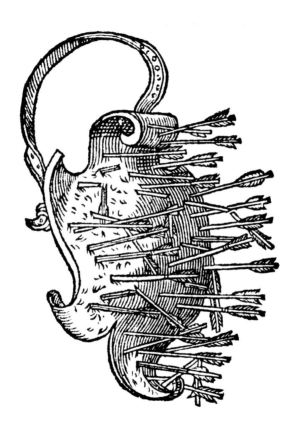

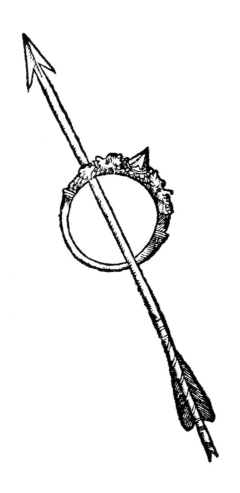

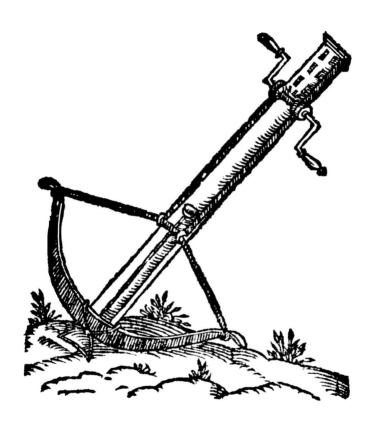

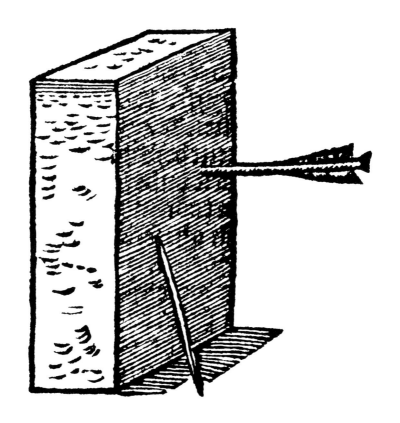

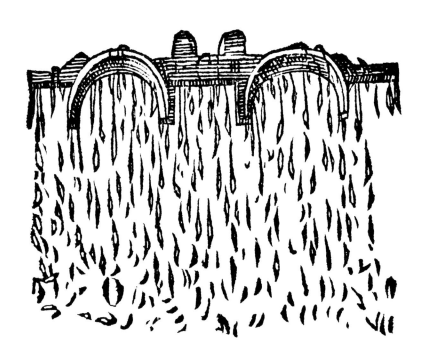

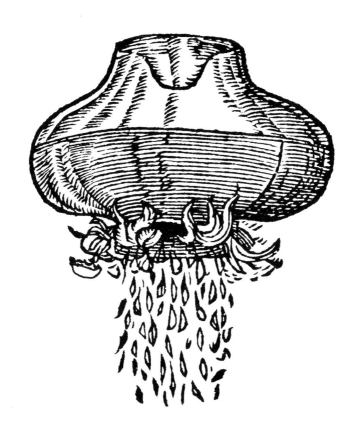

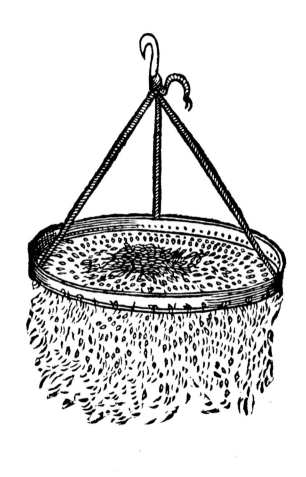

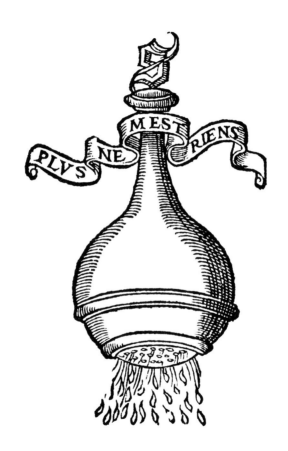

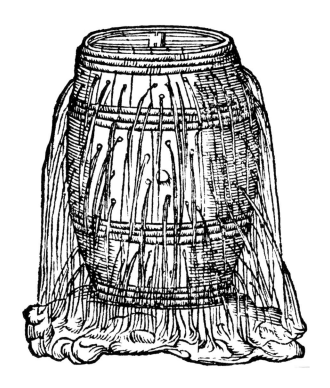

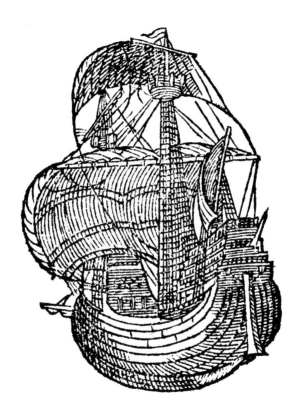

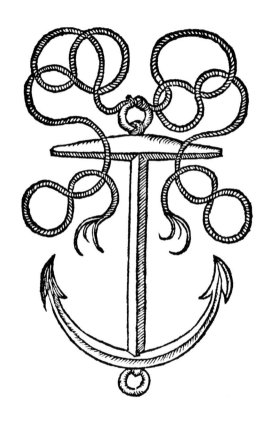

146

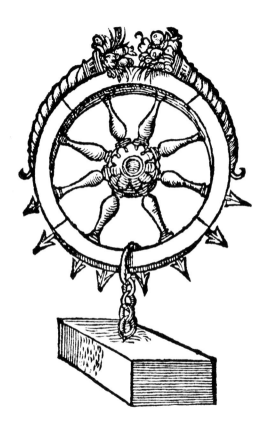

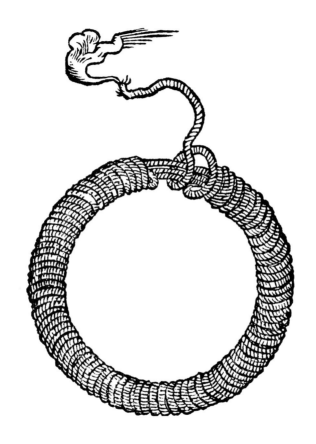

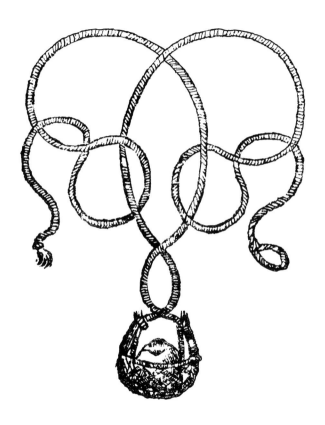

153

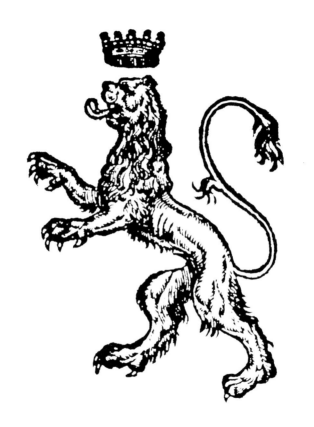

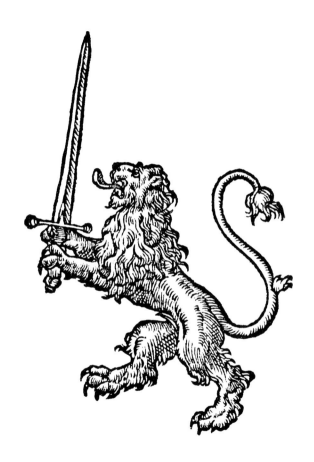

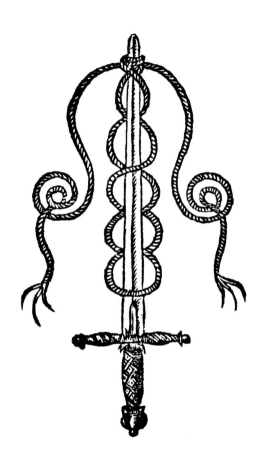

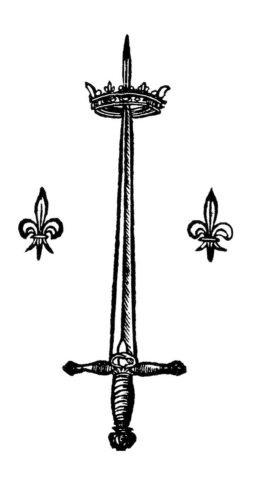

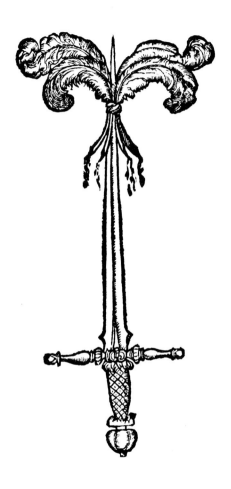

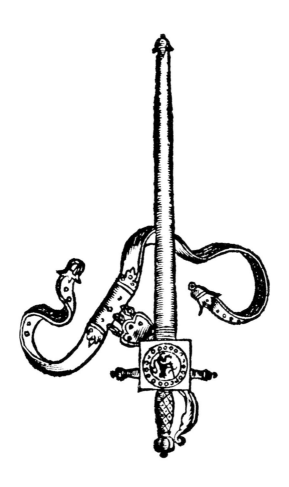

175

183

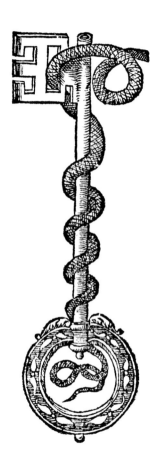

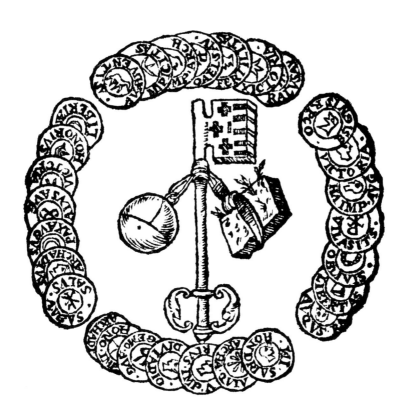

187

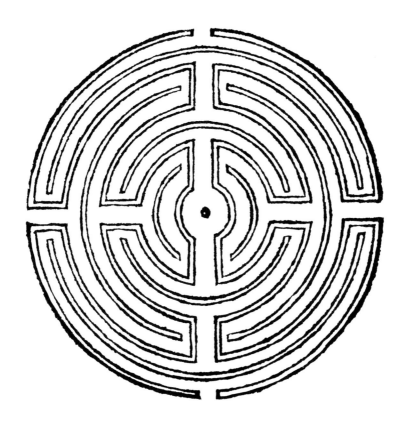

189

197

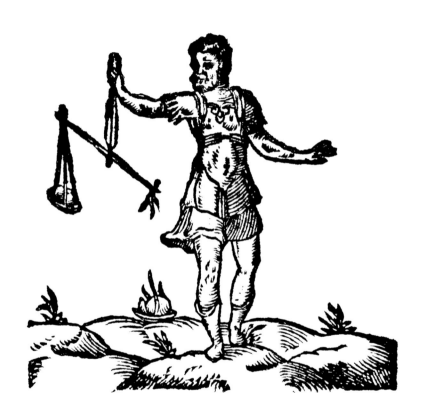

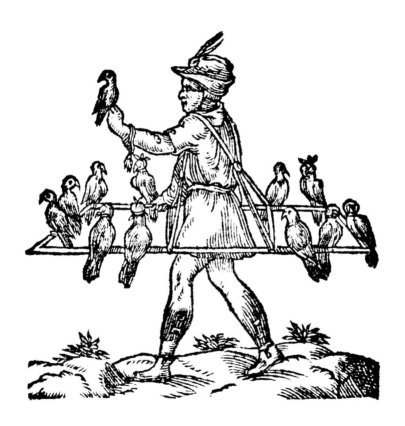

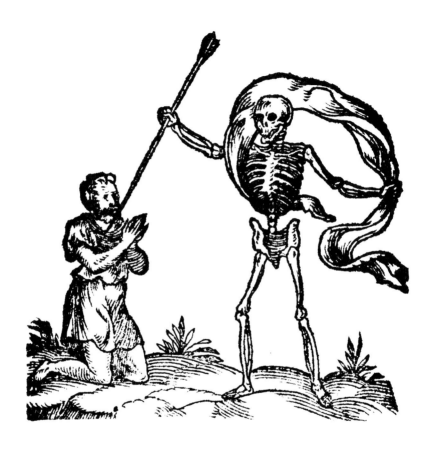

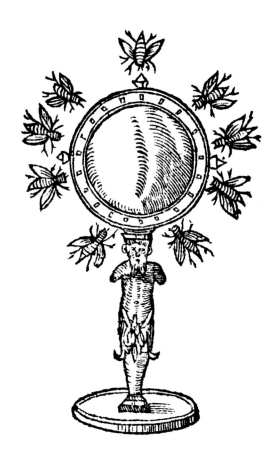

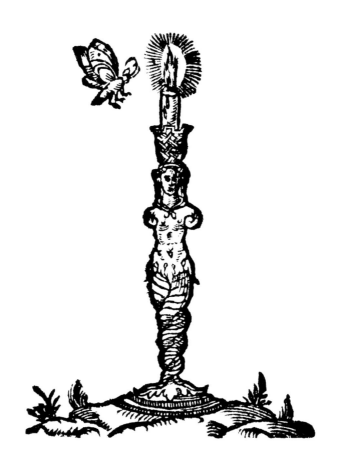

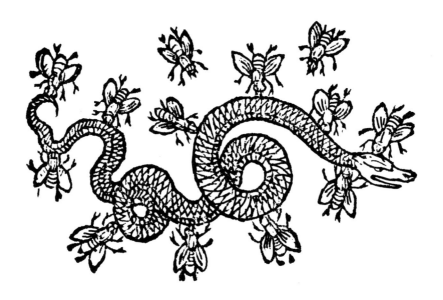

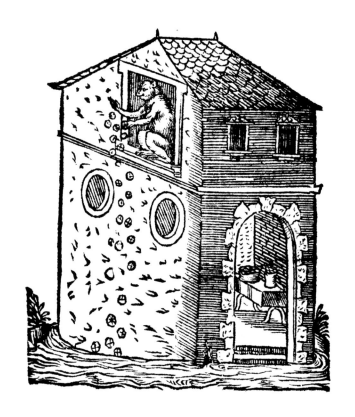

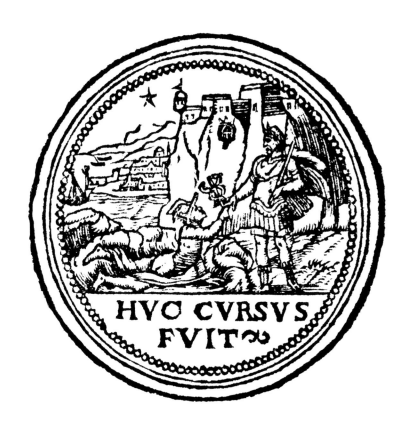

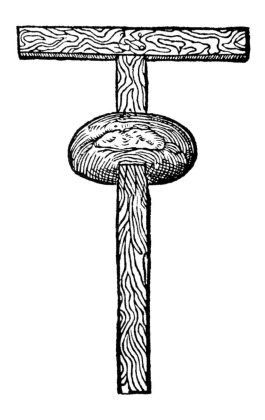

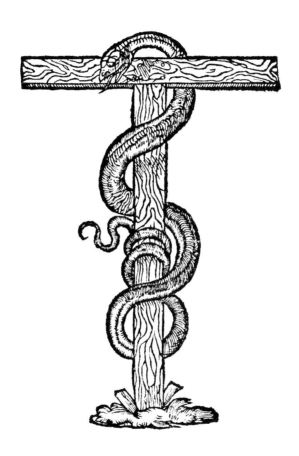

213

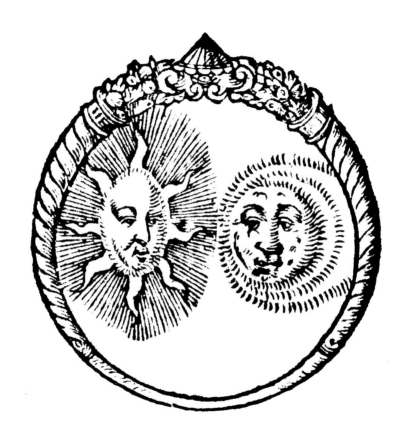

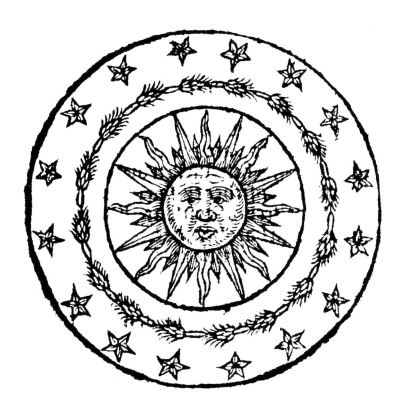

215

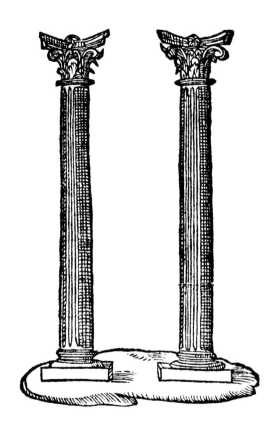

219

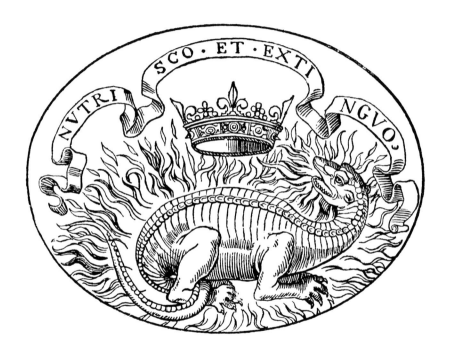

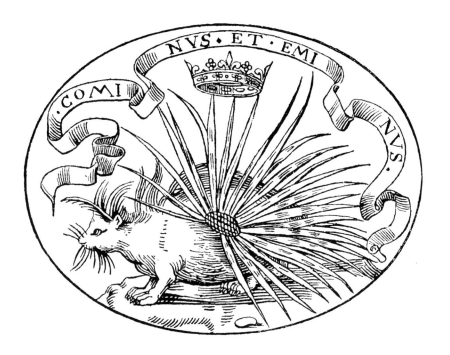

NEC DVM CES SIT AMOR

PRÆSTAT

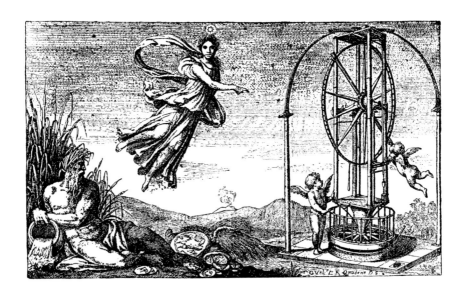

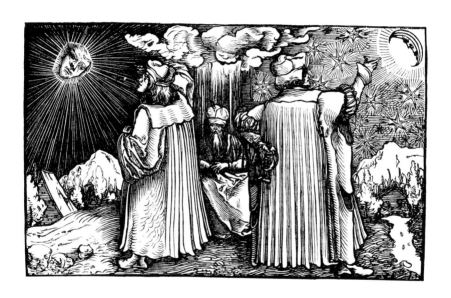

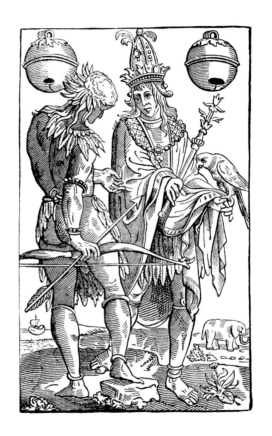

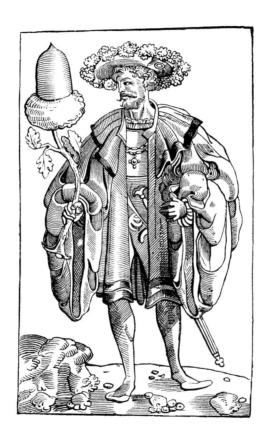

229

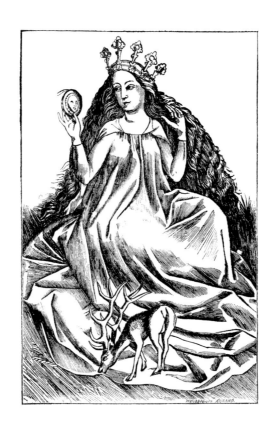

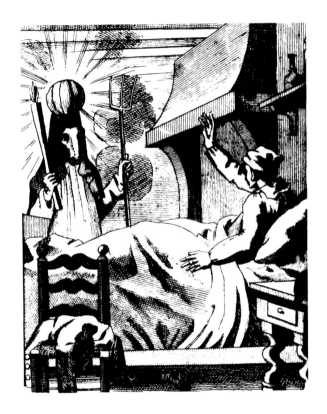

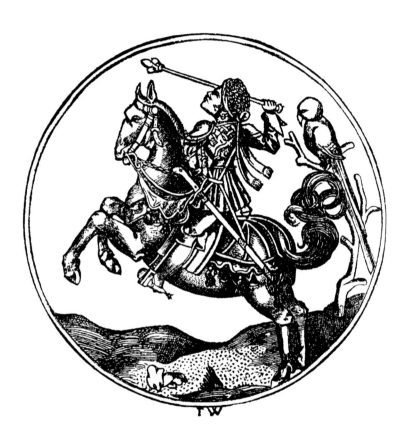

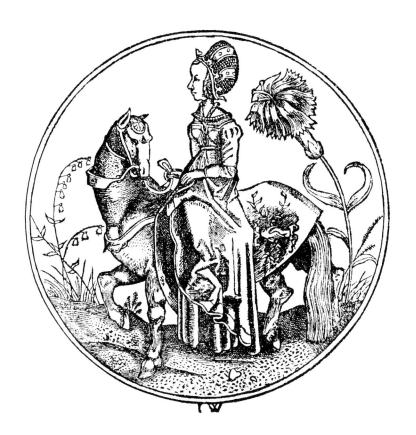

233

FVGIT INTEREA FVGIT IRREPARABILE TEMPVS ET FVGIT

ΙΟΥΝΙ ΚΑΙΡΟΝ

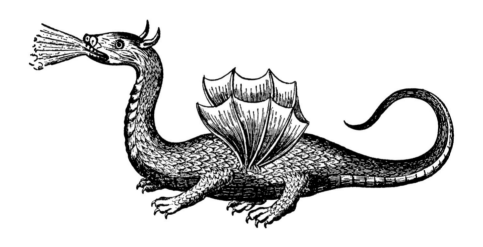

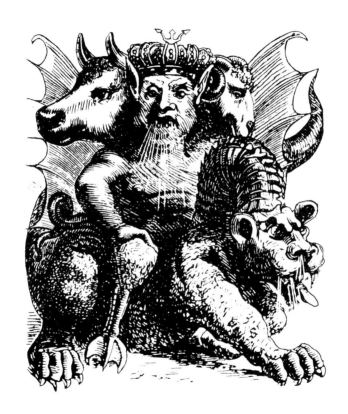

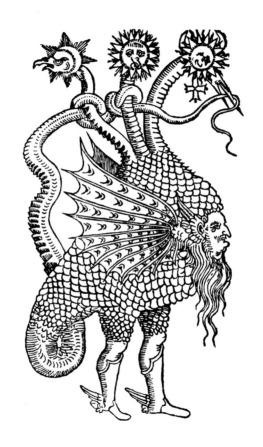

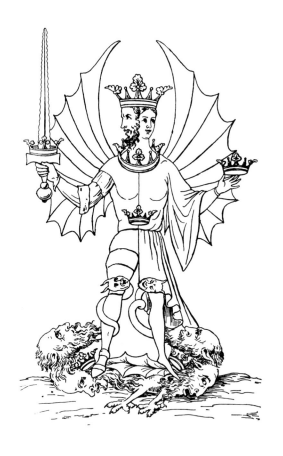

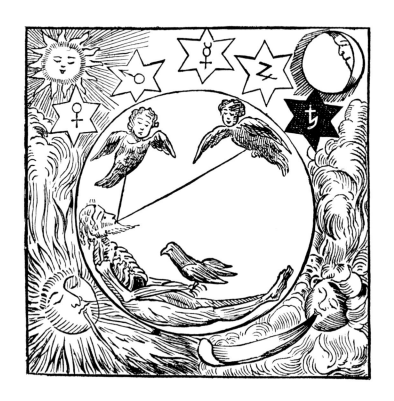

242

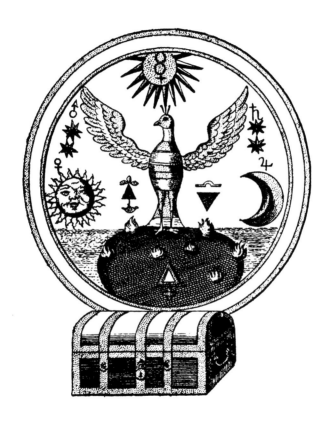

243

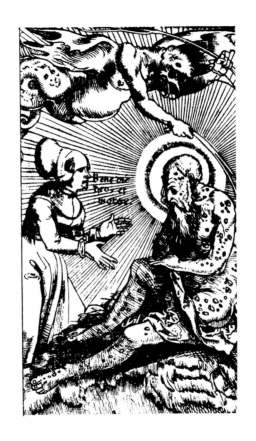

244

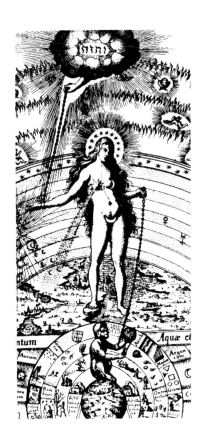

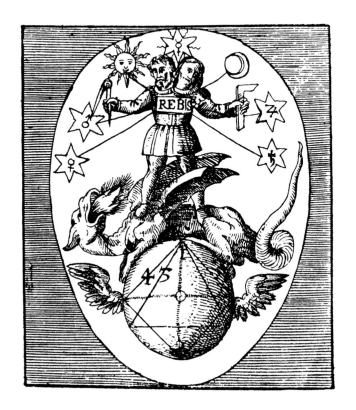

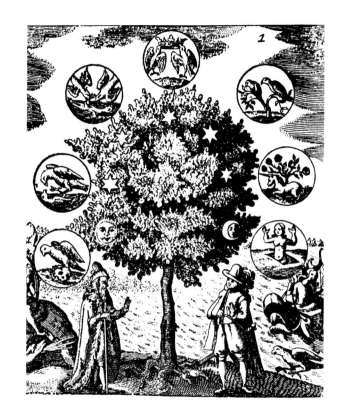

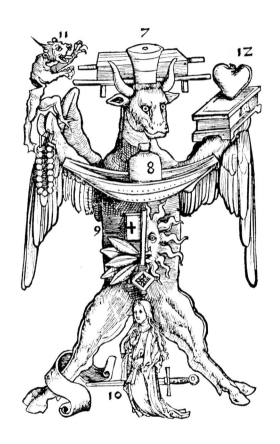

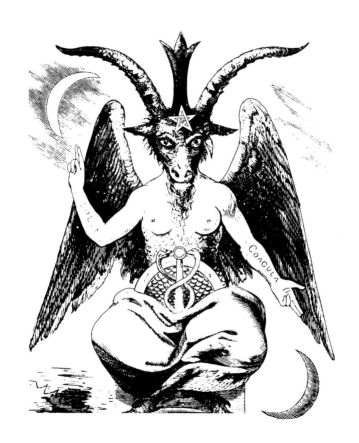

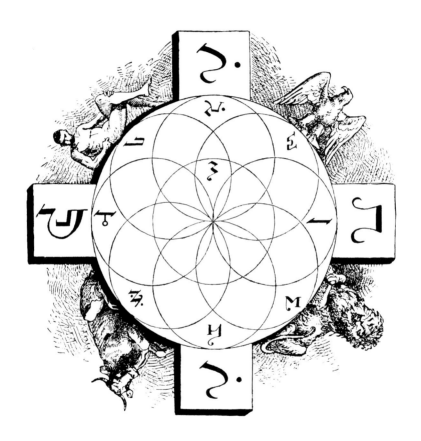

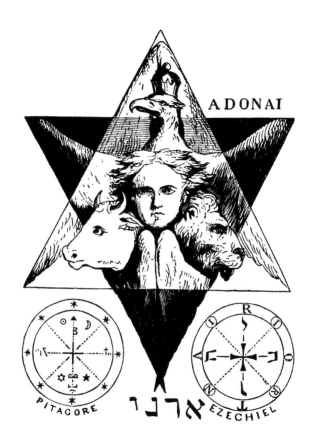

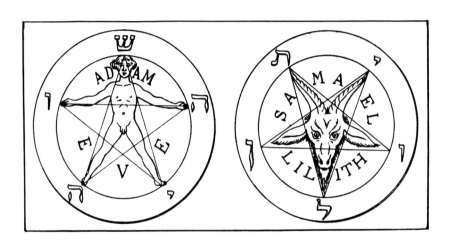

252

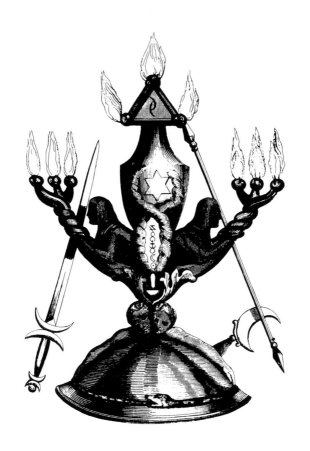

253

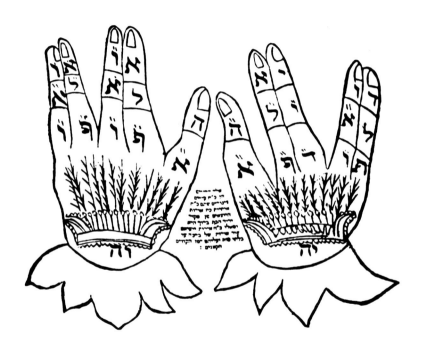

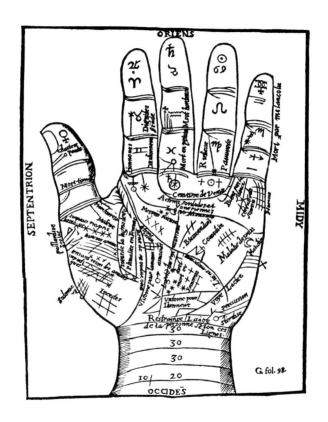

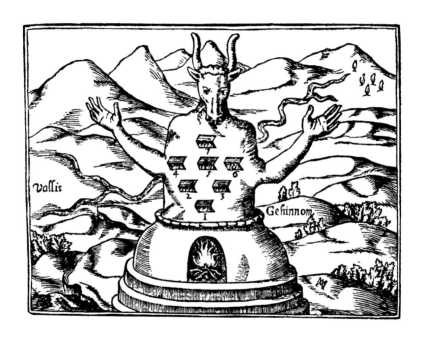

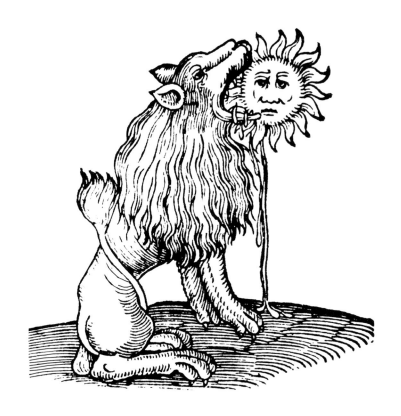

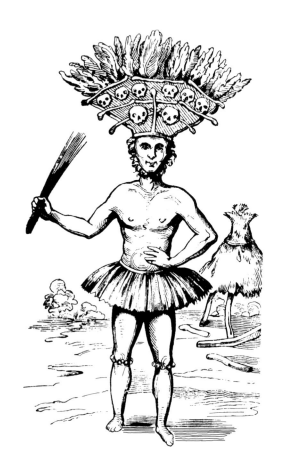

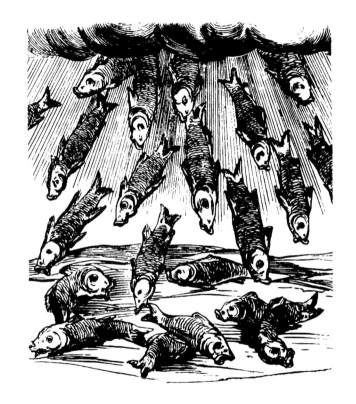

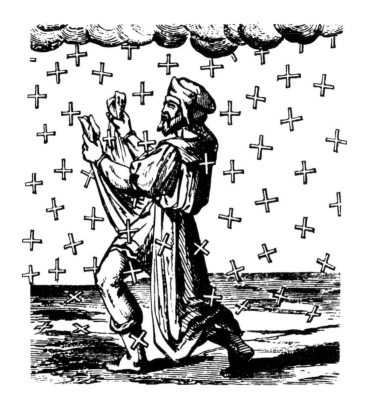

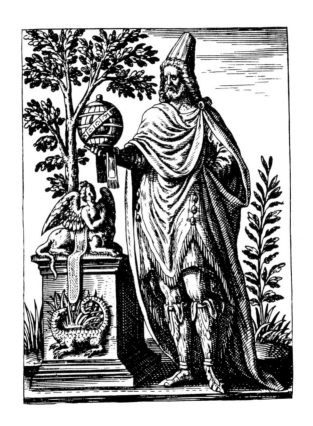

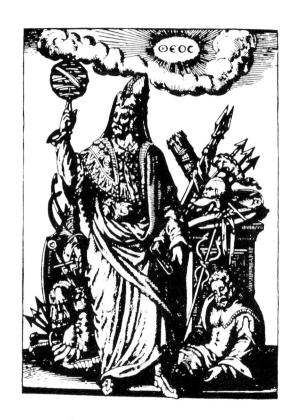

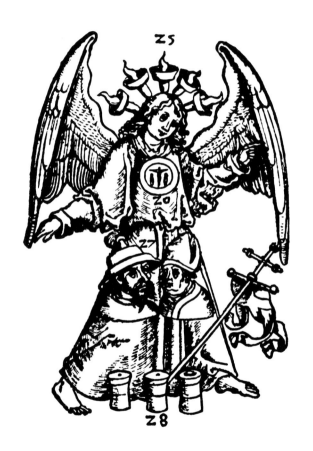

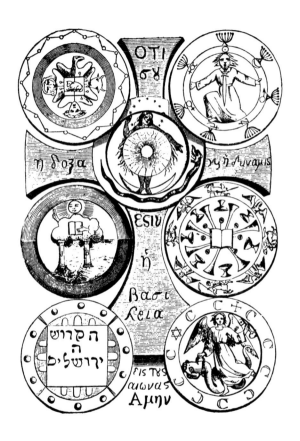

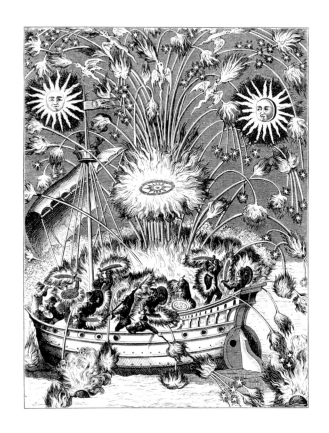

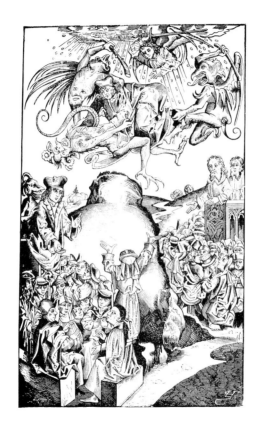

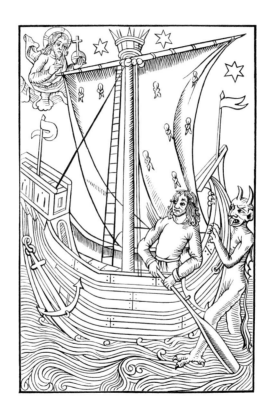

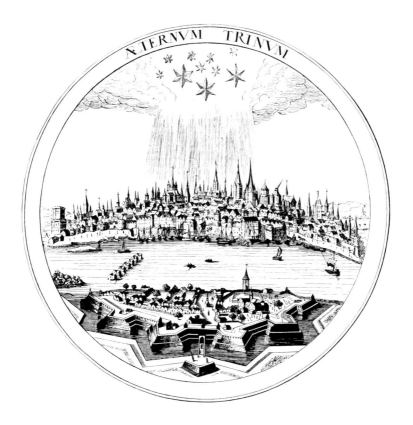

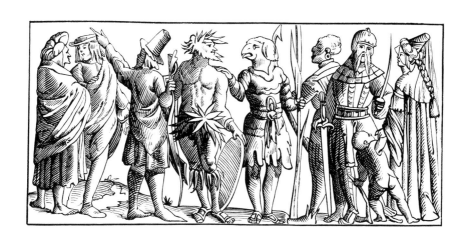

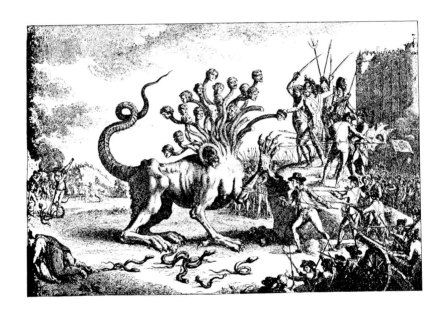